# HOUSE
# OF
# COATES

*by*
BRAD ZELLAR

*photos*
ALEC SOTH

COFFEE HOUSE PRESS
MINNEAPOLIS
2014

Coffee House Press books are available to the trade through our primary distributor, Consortium Book Sales & Distribution, cbsd.com. For personal orders, catalogs, or other information, write to: info@coffeehousepress.org.

Coffee House Press is a nonprofit literary publishing house. Support from private foundations, corporate giving programs, government programs, and generous individuals helps make the publication of our books possible. We gratefully acknowledge their support in detail in the back of this book.
Visit us at coffeehousepress.org.

Library of Congress Cataloging-in-Publication Data
Zellar, Brad.
House of Coates / by Lester B. Morrison ;
[Brad Zellar ; photographs by Alec Soth].
pages cm
ISBN 978-1-56689-370-1 (paperback)
I. Soth, Alec, 1969– II. Title.
PS3626.E3626H68 2014
813'.6—dc23
2014010614

Printed at Bang Printing in Brainerd, Minnesota

Excerpt from "In a Dark Time" (XXIV) reprinted from *The Collected Poems of Theodore Roethke* (New York: Doubleday, 1961).

# CONTENTS

A MAD PERSON
NOT HELPED OUT OF
HIS TROUBLE
BY ANYTHING REAL
BEGINS TO TRUST
WHAT IS NOT REAL
BECAUSE IT HELPS HIM
AND HE NEEDS IT
BECAUSE REAL THINGS
CONTINUE NOT TO
HELP HIM.

LYDIA DAVIS
"Break It Down"

MELVILLE, I THINK,
WILL NEVER REST UNTIL
HE GETS HOLD OF
A DEFINITE BELIEF...
HE CAN NEITHER BELIEVE,
NOR BE COMFORTABLE
IN HIS UNBELIEF;
AND HE IS TOO HONEST
AND COURAGEOUS NOT
TO TRY TO DO
ONE OR THE OTHER.

NATHANIEL HAWTHORNE
Notebook entry, November 20, 1856

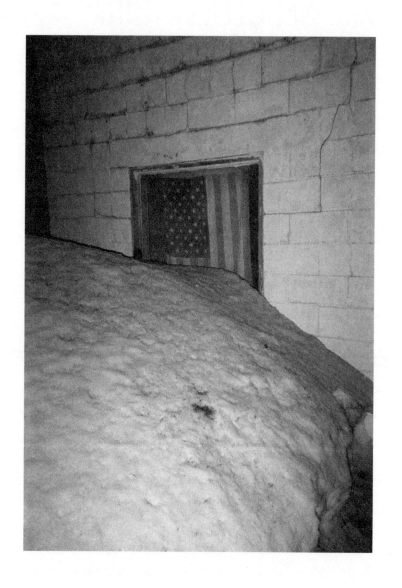

HERE'S TO THE prisoners of disenchantment, the lost, broken men bullied and inoculated against hope as children and eventually immunized against all notice or attention. To the lost boys and invisible men. To those who have been carved small by the glaciers of time and memory. To the fundamentally amnesiac, nurturers of the selective oblivion of the neglected. To the men who keep secrets even from themselves. To the ceaselessly retreating armies of the lonely. To the men who play hide-and-seek. Here's to Lester B. Morrison.

YOU KNOW LESTER as a man and a boy you refused to see or acknowledge. There are, from the time of childhood, Lesters all around you, and, try as they might, they never entirely disappear as adults, even if you still persist in not seeing them.

EVERY HOUSE is a halfway house. Every adult is a vulnerable adult. Everybody who lives with or among other people is a codependent. Everybody's some kind of junkie. Every dream has a giant eraser poised above it, just waiting to do its job. And every truly lost man knows exactly where he is.

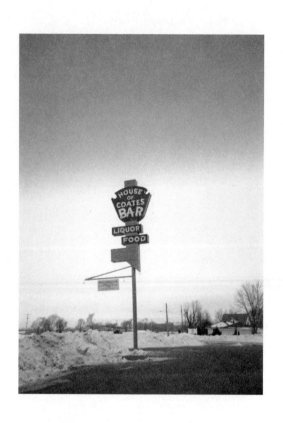

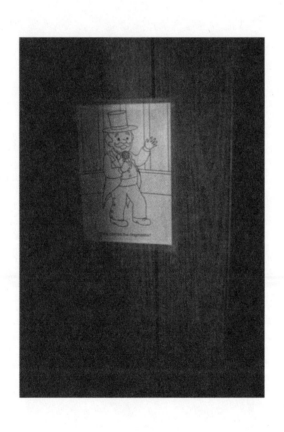

# HOUSE OF COATES SLEEPING ROOM RULES

IN COMPLIANCE WITH GOOD SANITATION PRACTICE AND FIRE PREVENTION,THE FOLLOWING WILL APPLY.

NO PETS ALLOWED.

EACH PERSON WILL BE RESPONSIBLE FOR YOUR OWN RUBBISH.

NO RUBBISH, BEER BOXES, OR NEWSPAPERS PERMITTED IN HALLWAY.

A CONTAINER WITH LID IS PROVIDED ALONG WITH EXTRA LINERS.

TAKE RUBBISH OUT TO DUMPSTER BEHIND BAR AS NEEDED.

DO NOT WASH DISHES IN SINK OR POUR GREASY LIQUIDS DOWN SINK OR TOILET.

NO ELECTRIC HEATERS OR BLANKETS OTHER THAN OIL FILLED ELECTRIC HEATER APPROVED BY MANAGEMENT. THESE APPROVED HEATERS WILL HAVE NO VISIBLE HOT WIRES OR FANS ON THEM. YOU MAY BUY YOUR OWN AND PAY A FEE OF $3.50 PER WEEK OR RENT ONE FROM US FOR $7.50 PER WEEK PLUS DEPOSIT.

NO AIR CONDITIONERS ALLOWED.

NO DEEP FRY COOKER OR HOT GREASE PAN FRYING.

SMOKE ALARMS MUST BE IN WORKING ORDER AT ALL TIMES. DO NOT REMOVE BATTERY UNLESS IT BEEPS WHEN GETTING WEAK. LET US KNOW IF THIS HAPPENS.

EACH PERSON WILL FURNISH HIS OWN TOWEL AND SOAP.

*Lucky Wally*
LUCKY WALLY

HOUSE OF COATES

THE HIDING CIRCUIT is in fact a sort of orbit. It is possible for a broken man to eventually break out of this orbit and end up alone in a kind of interstellar isolation, but there are usually predictable stages on his journey out. Way stations where men may live apart but that also offer communal portals frequented almost exclusively by similar sorts of lost characters. The men who run and the men who hide tend to be a deeply regressive fraternity, and as such their de facto clubhouses are largely governed by the cardinal rule of the original forts and clubs of boyhood: *No Girls Allowed.*

YOU MAY, OF COURSE, find men hiding, as it were, in plain sight, even in areas of extreme population density. Isolation is largely a psychological state, a breakdown of connection, but idealized isolation is something else, and is often the central component of whatever fantasies broken men still harbor.

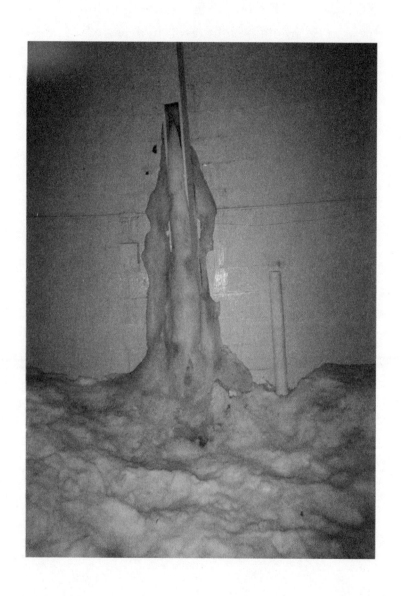

SOMETHING HAD HAPPENED to Lester once upon a time. A series of things, actually, that had the cumulative power of a cataclysm. That's not always the way it is with broken men, but that's the way it was with Lester. He seemed to have been born with what the Portuguese call saudade, a sort of eternal, metaphysical homesickness. He was lonely, but it wasn't the loneliness of a man sitting around bored and waiting for someone to call. Lester had an instinctive understanding of the difference between *apart* and *a part,* and knew that the syllabic bridge that somehow made *belonging* out of *be* and *longing* was a linguistic deception that was nonetheless incapable of obliterating the terrifying distance between such puzzling and perilous words. The world is one sprawling racket of collaboration, and there are those who don't carry the collaboration gene.

ONCE YOU CAUGHT your first glimpse of the refinery towers you were no longer in the city. There were freeways and interchanges and overpasses and then there was the sprawl of the airport and then you crossed the river and left it all behind and there was just the one straight road running south through the industrial scrub.

The Kingdom of Nah, Lester called it. Oz after the apocalypse. The dark place. The place of lonely men. Find a cheap place out there to hide and in the middle of winter you could convince yourself that you were somewhere in Russia.

It had been a fallback retreat for Lester for fifteen years. When he didn't have the money or the energy to get someplace warmer or farther away he would drive down there and hole up. He knew places where he could get a cheap room or small, bombed-out apartment where no one would pay him any notice whatsoever. It was a place where all the flimsy affirmations of the culture he abhorred could be effortlessly refuted.

The spectacle of the refinery was Ruskin's Pathetic Fallacy on the grandest and most wrenching scale, a place that mirrored the way Lester felt and the way he saw the world, and it was no metaphor: the smoke and fires of the refinery towers at night and the stench and soot and the tens of thousands of light towers did nothing but demonstrate how pervasive and impenetrable the darkness was.

It was like living in the furnace room of hell. Every place that did any sort of business out there catered to people who'd had the light beat out of them. Fifteen or so miles in any direction from the refinery was like a resettlement zone for all the extras from *Night of the Living Dead*. Just as you entered this zone coming from the north there was a sign along the road that read: *Toward Zero Deaths*.

Lester didn't have any idea what that sign was supposed to mean, but it meant something, and he noticed it every time.

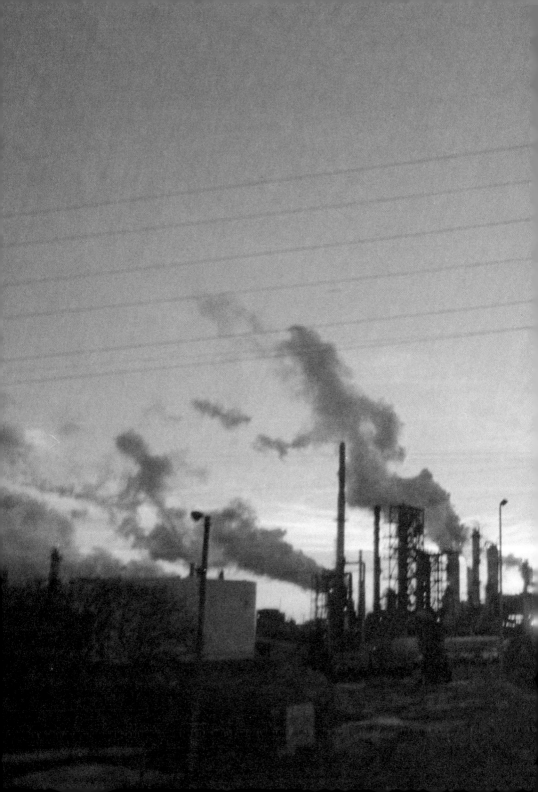

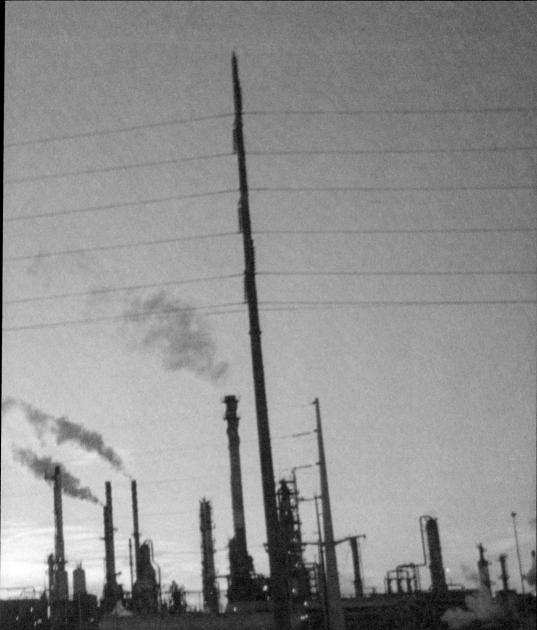

THERE WAS AN old Cessna on the roof.
The airplane didn't fly anymore. It wasn't going
to fly anymore. The airplane on the roof was just
another bad idea that someone had once had.
The place was a dark strip motel called the Airliner,
and the Airliner was done for. The sign out front
was no longer legible, and the owner now rented
rooms by the week or month. The refinery was just
up the road. There had once, in the not-so-distant
past, been a town directly across the highway
from the refinery, but other than a handful of
ruins and a dozen or so trailer squatters, nothing
was left but a neglected and practically invisible
cemetery that was the final resting place for a
bunch of old settlers and Civil War veterans.

That forlorn little cemetery could make a fellow
feel like he'd been dead for a hundred years.

Have you ever had the feeling that there wasn't a
soul left on the planet that remembered your name
or face or the sound of your laugh? That was a
Lester question, and his answer was yes.

NO ONE WOULD bother you if you slept in your car in the parking lot of the Airliner, and Lester had done so on occasion. In the middle of winter, though, he would pay for a room. There were always a few stray vehicles in the parking lot, every one of them a piece of shit.

The Airliner was right in the flight path in and out of the international airport. Jets were always going up into the clouds and falling out of the sky. Lester believed one day one of those planes was going to come down somewhere out there. He'd seen it in his dreams too many times for it not to be some kind of prophecy.

"Mark my words," he would say.

Lester liked to tell people to mark his words, and in some sense he likely meant it literally. You'll often find that these men who most long to disappear are also in some inexplicable way desperate to make some sort of mark on the world, and most in need of some assurance that they aren't—and won't be—entirely forgotten.

The refinery was slowly but surely annexing land on all sides and fencing it off with razor wire. Farther north and south of the refinery there were clusters of what the temp agencies called "light industrial" factories, places that made things like mud flaps, hoses, windshield wipers, packing materials, ice scrapers, and artificial Christmas trees. Pretty much all the workers at those places were itinerants.

Lester wasn't more than forty miles from the place he'd grown up, but he might as well have been on another planet. Which is exactly where he wanted to be.

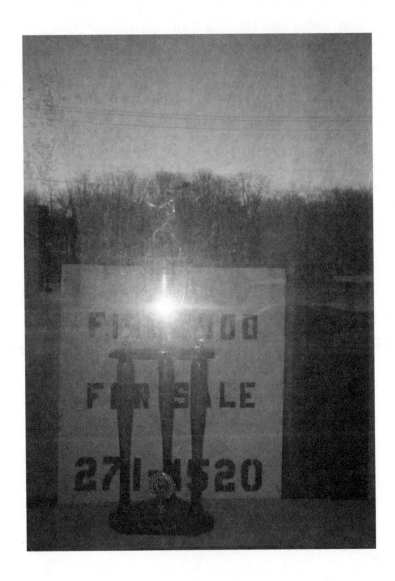

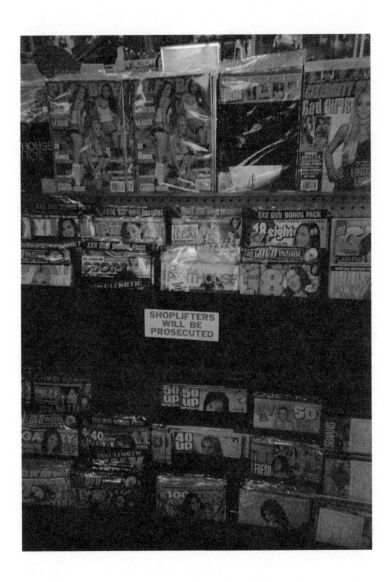

THERE WEREN'T MANY permanent residents out along that stretch of the road. The refinery's hulking presence made the idea of human permanence laughable. Any sort of permanence, really. There didn't seem to be any children anywhere within at least a dozen miles of the place.

There were some old-timers dug in out there, mostly in the trailer park back by the river behind the cemetery. The faded sign outside the trailer park had only two words on it: *Trailer Park*. Weather permitting, the remaining residents sat outside with their oxygen tanks, smoking and drinking beer. They weren't regarded as a welcoming bunch.

THE CLUBHOUSES of the hiding men are
generally public places—strictly speaking,
at least—but they are most often tucked away
in the country, at the outskirts of small towns,
or in neglected parts of big cities. If you were to
happen into one of these places by accident there
would be no mistaking it as anything but a meeting
place for men in hiding.

There were a number of such places in the
Kingdom of Nah; a truck stop—the Travel
Plaza—and several refinery bars and cafés,
and they could provide either mute communal
refuge or a pulpit for the twisted philosophy,
paranoia, and conspiracies of the broken men.

THE TRAVEL PLAZA was a sprawling place
and all-around lonely-man magnet. It had showers,
a laundry, restaurant, game room, and lounge.
You could buy groceries or pornography or
fireworks there, as well as all manner of worthless
geegaws, patriotic accessories, and jerked meat
products. There were a handful of regular
prostitutes who used the place as a sort of locker
room and staging ground. Some of them danced
in the refinery bars a bit farther south down
the highway.

Lester would contend that the Travel Plaza was
as inspired and visually arresting as any museum
installation in America. Every time he went in
there he found something that almost made him
feel as if he was living in an age of wonders.

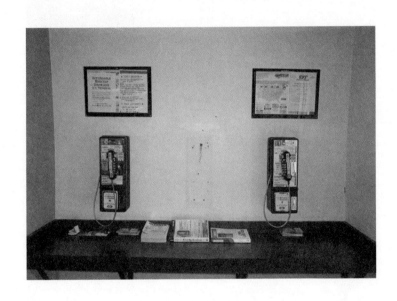

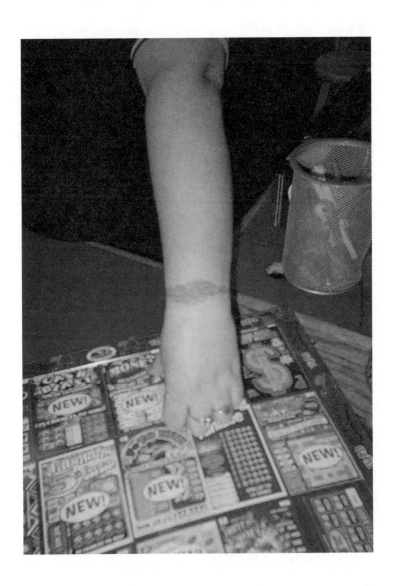

THE NOTION OF INVISIBILITY is a neat
fantasy when you're a hyperimaginative boy,
and when you are still able to think of it as a power
you can turn on and off at will. But when there
comes a time that you no longer seem to have any
control over it and when you start to feel as if no
one can see or hear you, or *wants* to see or hear
you, that's when you might once again embrace
invisibility as a fantasy you can control.

You can run. You can hide yourself away. You can
choose to be as unseeable as possible. That's what
Lester did. There was obviously conflict and
confusion in this choice. And the men on the
hiding circuit tend not to be distinguished by any
particular aura of serenity, which isn't to say that
literature of gossamer nonsense couldn't be
summoned for romantic justification when needed.
There are a lot of plenty smart men hiding in
America. Lester was a smart man.

Family, childhood, and memory are almost always
touchy subjects with lost, broken men, but the
reasons for the evasion aren't always cut and dried.
A happy childhood can be almost as crippling and

inhibiting to social growth as an abused or neglected one. You'll find an awful lot of stunted, nostalgic characters in retreat from life.

If the earliest memories are of a time of relative security and simple contentment that is markedly discordant with later childhood and its experiences of peer pressure, structure, bullying, and other such adaptive nightmares, and if those later relationships and patterns become the defining experiences of early psychology and the way we come to see our place in the world, then it makes a sort of perfect sense that a man might hold tight to those truly formative memories. Paradise before the fall. In the crucible of persecution and loneliness both philosophy and intensely personal theologies are often born.

Lester's own childhood had gone downhill in a hurry.

He once received an Alvin and the Chipmunks coloring book for Christmas. He could not bring himself to color in the pictures; it seemed an unnecessary violation. The coloring book was an intended collaboration that was for Lester perfect

as it was. The black-and-white line drawings were intoxicating enough as launching points for flights of fancy.

If he were to color in the book he would be subjecting its pages to inevitable wear and tear; there would surely be mistakes. He carried that coloring book with him in a plastic bag in his knapsack, intently inspected its covers and pages each night for signs of wear. He treated the Alvin and the Chipmunks coloring book like an archival object that had been entrusted to his care. He couldn't bear to be parted with it, and studied it obsessively at every opportunity. Other children noticed this, of course; it is the nature of children to take careful note of obsessive vulnerabilities, and to mock or disrupt them whenever they can.

One day at school Lester's Alvin and the Chipmunks coloring book went missing, and he was inconsolable. For several months he pored over his copy of *The Hardy Boys Detective Handbook* and set out to find the thief or thieves of his coloring book. This dogged investigation

was ultimately fruitless and only led to more
mockery and further marginalization.

There was another nostalgic hotspot in Lester's
memory. He'd had a cousin who received an
elaborate dollhouse for Christmas one year, and the
dollhouse had fascinated Lester for several years.
He was drawn to that tiny and tidy little world.
It looked so manageable, a refuge or sanctuary
for the loneliness that was already growing in him.
He longed to live in the dollhouse, tucked away
in the corner of the girl's bedroom. She would
eventually grow up, and there would come a point
where he would be left entirely alone.

He made the mistake of asking for his own
dollhouse one Christmas and had never heard
the end of it.

So that was Lester as a boy. Awkward, different,
harassed for his otherness, for his mute defense
strategies, which were, of course, wholly ineffective.
There were boys in his neighborhood who had
bedrooms full of trophies and ribbons, one more
great mystery to Lester. Some people just woke up

every day to discover they'd won something new. You might picture Lester, later, in his basement, intently assembling Famous Monsters models and replicas of hot rods. Or reading superhero comic books or the stories of Robinson Crusoe and the Swiss Family Robinson. These things he would eventually recognize as fantasies, and they provided a good deal of the fuel for both his disenchantment and his retreat from the world.

A broken boy needed consoling fantasies, and Lester began actively to dream of places where he could indulge these fantasies. And at some point in early adolescence he started to have the intense and very real sense that he had been shipwrecked.

Most broken men become through time and circumstances shipwrecks, and end up feeling shipwrecked. Lester went about it the other way around; he was precociously shipwrecked, but it took a couple of decades for him to recognize that he had somehow come to inhabit and carry around with him the wreckage of his own ship.

This shipwreck was his life, and the island on which he'd found himself shipwrecked was the world. He once read somewhere about a lonely British inebriate who spent well over a decade and most of his fortune booking cabins on increasingly ragtag Pacific ocean steamers, always with the hope that he would eventually find himself shipwrecked on some forlorn island where he could at last crown himself king. It never happened, of course, and he finally ended up in Hawaii, broke and begging for liquor money from tourists.

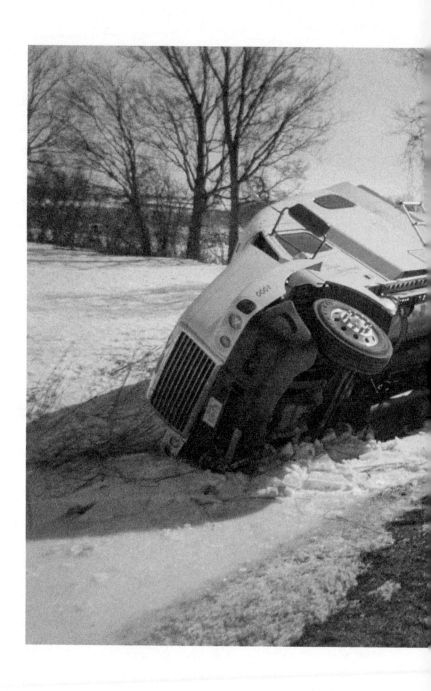

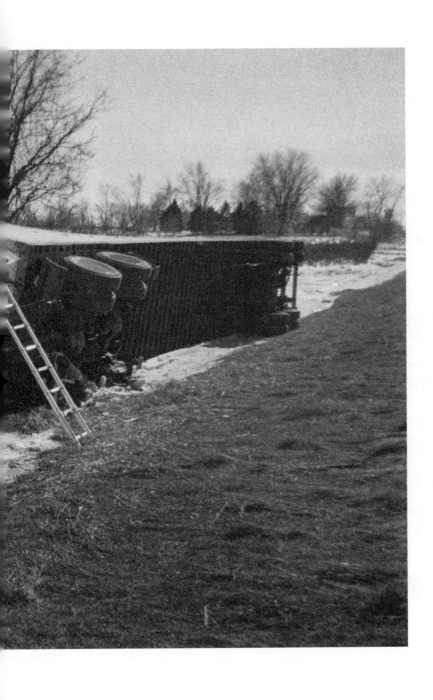

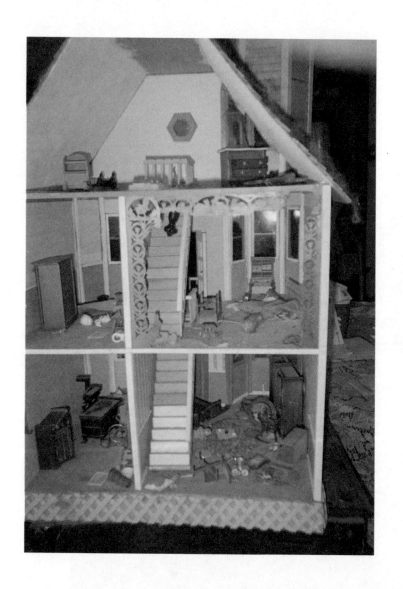

THE LITERATURE OF hermits and solitude
is full of serenity, self-discovery, and wisdom;
it's a world of saints and scholars. You'll encounter
the occasional ornery or eccentric character,
but even these tend to be homespun archetypes.
Most of the legendary recluses embraced solitude;
their message seemed to be that a man's business
was to find his place in the world and hold his
ground. The writing is full of so much blather
about contemplation and silence, and so much
preachiness, that it leeches a good deal of the
essential mystery and motivation out of the act
of retreat.

Even the nihilists and the most philosophically
bereft loners can't kid themselves. A person can't
properly hide in this world unless they believe
there's someone out there looking for them.
There's a good deal of ego invested in the act
of hiding. Or maybe these fugitives think there's
someone out there in the world who wants
something from them that they're not prepared
to give. The sad truth, of course, is that the world
seldom wants much of anything from such people,
and that is a truth that could do nothing but

further hurt the feelings of men who had had their feelings hurt so many times and in so many ways that they could no longer feel anything but hurt.

Lester wasn't just running, though. He was looking for something, even if he wasn't quite sure what he was looking for or even willing to admit that he was looking. The day such characters finally admit to themselves that they actually are looking for something and start mulling what that something might be is when they truly become missing persons. Not missed, necessarily, but *missing*.

SOME LESTERISMS:

The devil is a breeder.

An invisible man spends a good deal of time
wrestling with the word *repellent*.

The world is a manhole.

Innocence is the last great American myth.

Hope is an imposter bird.

God's nothing but Einstein in Vegas.

Dante should have suffered more. Scrooge's hell
was much more terrifying.

LESTER'S MOTHER had been pretty, and she had been kind. Regarding his family, you weren't likely to learn much more than that from him.

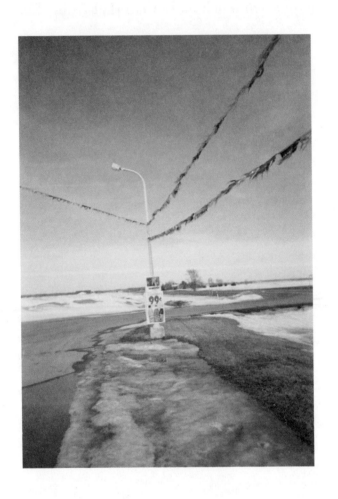

THE FANTASIES WERE all in some essential way the same, but they were continually undergoing slight transformations of increasing specificity. There were the tree houses and caves, of course, and for a time Lester dreamed of living in an abandoned car wash in the "most ruined and godforsaken town in America," a place where it would no longer ever occur to a single soul to wash a car.

OF COURSE LESTER had had jobs, the typical
sorts of jobs broken men tend to find and not do
very well or keep for very long. But jobs were hard
on Lester. They were collaborations, listless or
half-assed, generally, but still; there was proximity
to other people, orders, directions, a hierarchy,
expectations. He knew that wherever there was
anything resembling a pecking order he was
certain to bear the brunt of the pecking.

He seemed to be able to get money when he
needed it, though. Loneliness could be subsidized;
broken men were known to have patrons—mothers
and sisters, often. Or government and religious
institutions if such men would have any truck
with such agencies.

Lester wasn't one of those. Some of the hidden men
were military veterans, the armed services having
long served as a temporary hiding place for men
who weren't sure where they belonged. Lester
wasn't one of those, either. Whatever the source
of his money, it didn't cost much to be Lester.

He didn't seem to fit any of the obvious pathologies of a man running from the world and responsibility. He drank, and sometimes drank too much, but his orbit didn't revolve around alcohol. And he would take drugs if they were available, but he didn't like to pay for them. As broken men go, he was relatively disciplined. Lester's philosophy, as it were, required a certain amount of control, and a sloppy man desperate for drink or drugs had a hard time being consistently inconspicuous.

Lester was a brooder, mostly, but he could get excitable if some idea struck his fancy or he got on board one of his hobby horses. He'd been thinking about what he was doing his whole life, scheming about disappearance and its enticements and possibilities. He also had a lot of anger, and anger needs an outlet that isolation doesn't tend to provide. It's hard to lash out at the world when you're desperately trying to retreat from it. Nothing ever gets resolved. That combination of anger and isolation, though, is what drives lonely men to write rambling manifestos.

IN MID-FEBRUARY Lester was evicted from the Airliner. He hadn't done anything wrong. The only thing you could really do wrong at the Airliner was not pay your rent, and there was even a good deal of wiggle room on that.

The owner left a notice on Lester's door that the place was going to be razed, and he needed to get out by the end of the week. "Sorry, fella," the man had written on the bottom of the note.

Lester moved his stuff down the road to Hampton, where he got a two-room apartment above an auto body shop. He'd spent time in Hampton before. It wasn't much to speak of. There were a couple bars and a church, a little ball field, and moldering tennis courts. He didn't know a soul, and nobody even seemed to notice he was there.

It had been a hard winter, and Lester was feeling as if his orbit had grown too tight and wobbly. Any day he expected to feel the pull, and to get yanked clear off the planet. Out there in the Kingdom of Nah he could walk roads that went nowhere. Walking gave him the sense that he

was still moving. There was snow on the ground.
It had snowed nearly every day for two months.
Many of the roads were poorly maintained.
A number of them had never seen a plow. The entire
area was so fouled that even in the dead of winter
Lester would see steam rising in noxious clouds
from the fields of snow. The poisons were making
their way through two or three feet of snow
and creating swirling scarves of steam in the
freezing air. Lester guessed that if he spent enough
time poking around in some of those trailers out
by the river he'd eventually turn up some
two-headed babies.

He was in a dark place, but he'd been in darker,
and there didn't seem to be any question that
he was headed for even darker still. Lester was
always reading; he had boxes of old books and
magazines he'd fished out of library and thrift
store dumpsters. He had a stack of old
sketchbooks and a bunch of disposable cameras
he'd found in a clearance bin at the Travel Plaza.
On the rare occasion that someone asked him
what he did, he claimed he was a videographer.
He was always trying to make something.

It didn't have to be beautiful; Lester just wanted to make something that felt real to him, something that felt like the way it was. But nothing happened. And day after day nothing just kept on happening.

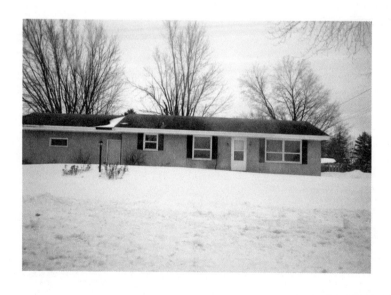

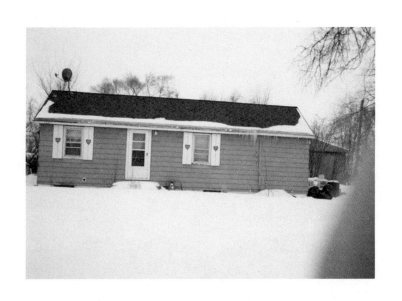

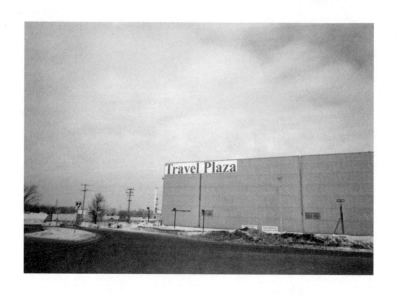

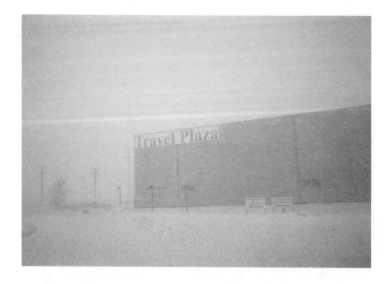

LESTER WAS ONE of those people who refused to believe that man had ever set foot on the moon. The whole idea struck him as a violation of the imagination. Of all the things in this world that it might profit a man to believe, Lester chose to believe that Neil Armstrong took his giant step for mankind in a studio somewhere in Hollywood. "You open a door like that," another broken man once told Lester, "and you have no goddamn idea how much reckless nonsense might come marching through it. And you can for damn sure bet that at the very end of the line you'll find God herding his rough beasts along and cackling."

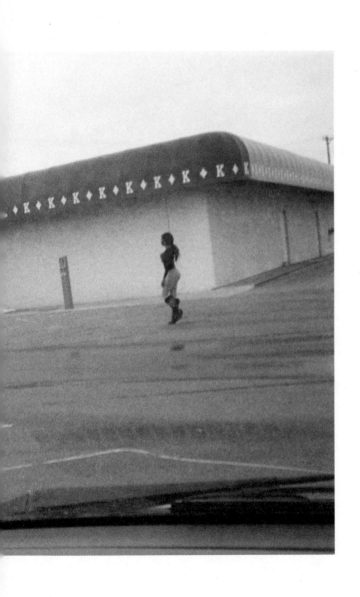

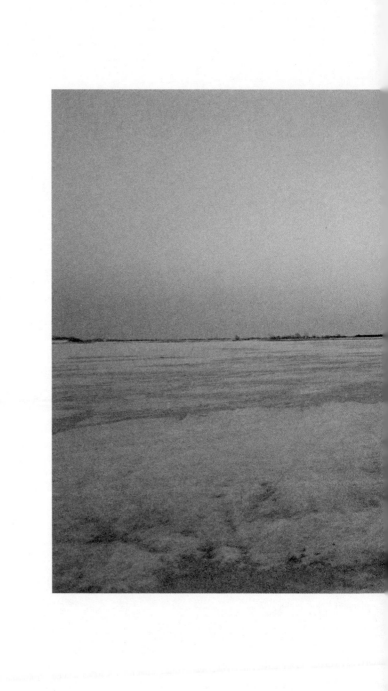

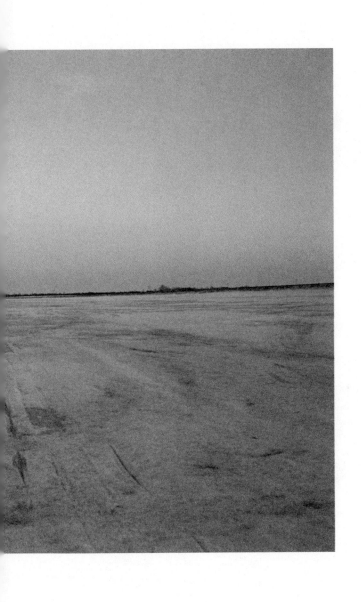

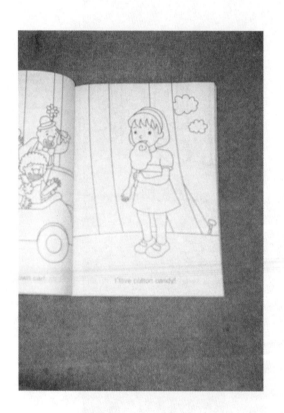

I love cotton candy!

HE FIRST RAN into the woman at the Travel Plaza, where she was doing laundry. There was no saying, really, how old she was, or even whether he found her attractive in any sort of conventional sense.

She was a pale woman, small and soft, with dark eyes that had some suggestion of fearlessness in them. She took things in, and there was none of the evasion Lester had come to expect. She looked right at him and he knew that she was seeing him, and that was more than he had learned to hope for from any woman in the world.

He couldn't remember the last time he'd spoken to a woman in anything but a customer service capacity, but he spoke to this woman.

"I bet it's hard to keep things clean out here," he said.

"I've got some different ideas about clean," she answered.

Lester asked what sorts of ideas those might be.

"Different," she said again. She was transferring a load of clothing from a washer to a dryer. Lester noticed that she separated her colors.

"Whites," she said, speaking the word even as it was still hanging in Lester's mind. "You know what color they're supposed to be, and if the dirt doesn't come out at least you know what you're up against. No stain can hide."

Lester merely nodded.

"If you'll have a cup of coffee, I'll have one too," she said. To which Lester replied with only a hesitant yes that came out sounding like a question.

"Yes?" she said. "You know where the coffee is. I'll come over there in a minute."

Lester wandered over into the restaurant and took a seat in a booth near the window. He experienced a moment of terrible doubt. What the hell was this? What did he think he was doing? The woman appeared and settled in opposite him in the booth.

"You live out here?" she asked.

Lester shook his head yes, then no.

"I'm staying in a place up the road."

"Doing what?" the woman asked.

Lester shrugged.

"You don't know?" she said. "A man who doesn't know is in trouble in this world."

Lester allowed that this might be true.

"What's the nature of your trouble?" she asked.

Lester thought about this for a moment.

"Just the way things are, I guess," he finally said.

"And what way is that?" She had her arms crossed on the tabletop and was leaning intently in Lester's direction, fixing him with those dark eyes.

"Broken," Lester said.

"I figured."

They were silent for a moment, but she did not take her eyes from him. There was a word tattooed neatly on the inside of her left wrist, but Lester couldn't make it out. She saw him studying it and held out her wrist for a closer look.

Lester shook his head, and she took a pen from her jacket pocket and reached across the table and spelled out the word on Lester's placemat: HARPAZO.

"You know that word?"

Lester said that he didn't.

She stared at him. "You should," she said.

They drank their coffee. Everything outside the booth was moving in slow motion and shadows. Lester felt as if he was in an aquarium, and wondered if he was dreaming.

"Well, broken man, I need to finish my laundry," she said. "My name is Majel Eames. I take care of my father down near Coates. Perhaps we'll bump into each other again."

And with that she was gone.

THE WORD WAS not in the dictionary Lester had, so he drove thirty miles the next day to a town that had a library.

He found the word on the internet.

HARPAZO (v.): 1) to seize, carry off by force. 2) to seize on, claim for oneself eagerly. 3) to snatch out or away.

On the same page where he found the word there was a painting of a large city in chaos. Buildings and cars were in flames. Bodies, with arms raised, were floating free of the earth.

*Oh, fuck,* Lester thought. *This is about religion.*

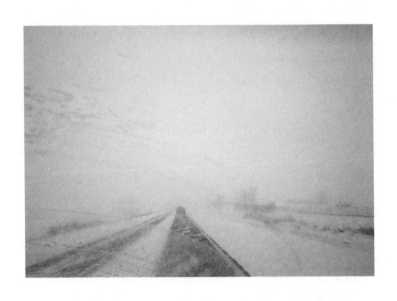

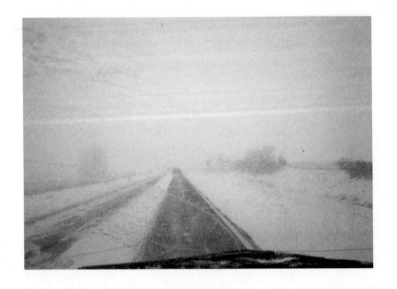

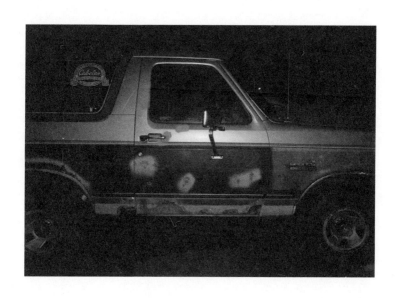

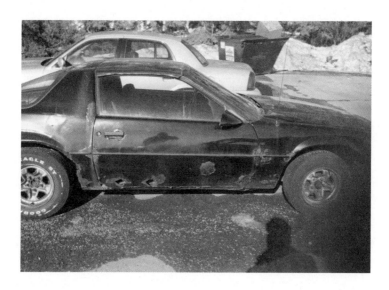

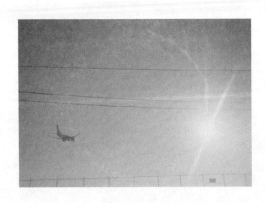

MAJEL LEARNED LESTER'S name. He told
it to her over coffee at the Travel Plaza. She gave
him a little comic book with the title *Will You
Be Ready?* He flipped through it as she watched
him quietly. It was a dark piece of work, full of
apocalyptic scripture. Lester was familiar with
that drill, and told Majel so.

"What I don't get about this stuff," he said.
"Is where's the light? You call this a happy ending?"

"I do," Majel said. "It's not about light. It's about
finding a way to live in the darkness."

Lester shook his head. "I probably haven't hit
bottom enough for this business."

"There is no bottom," Majel said. "There's only
the end. You don't hit the ground, you go through
a door. And you keep going until you find that door.
If you've got a hole in you, you can't live in this
world unless you figure out what goes in that hole."

"The Lord is a shoving leopard," Lester said.

"You aren't that smart," Majel said.

HE WAS LONELY, and he continued to see
Majel. He learned that she had been married to
a man who had been killed in a car wreck not five
miles from the trailer where she lived with her
father. Her mother died when she was young.
She cleaned motel rooms in a suburb to the north,
and had been named after an actress on *Star Trek*.
She read the Bible, had been sober for ten years,
and did word-search puzzles. She had been born
a day earlier than Lester, in the same year.

She was kind to Lester, but she would not admit
to him that her faith had made her happy.

"It's not about being happy," she said. "It's about
knowing why you're here."

"And why are you here?" Lester asked.

"To take care of my father," she said. "And to
listen to you, and suffer."

 She was joking about that last part, Lester could
tell, but he also could tell that she was a woman
with a lot of darkness in her. At some point she'd

groped around in that darkness and pulled out the
bloodiest version of Jesus she could find, a Christ
drenched in blood as black as motor oil. She was
attracted to a suffering even greater than her own,
and the promise of something better beyond it.

Still, he liked her, and liked being with her.
She told him he was a miracle and it both moved
and amused him.

LESTER HADN'T TOUCHED a woman in over a decade. But he'd wanted to touch a woman since he was old enough to imagine what touching a woman might feel like and mean. He'd just never quite figured out how to make it happen or how to make it last.

The first night Majel spent with him in his filthy apartment he had been grateful that she knew what she wanted from him and knew what she was doing. He had been terrified, but it was good, and easier than he had any reason to expect.

Later, as they lay together quietly in the darkness, Majel had suddenly spoken aloud a passage from Luke: "I tell you, on that night two people will be in one bed; one will be taken and the other left."

Lester figured he ought to be spooked by something like that, but he was not spooked.

The next morning he ate breakfast with a woman for the first time since he was a child.

HE TRUSTED MAJEL. He couldn't trust anything else that was happening, but he trusted her.

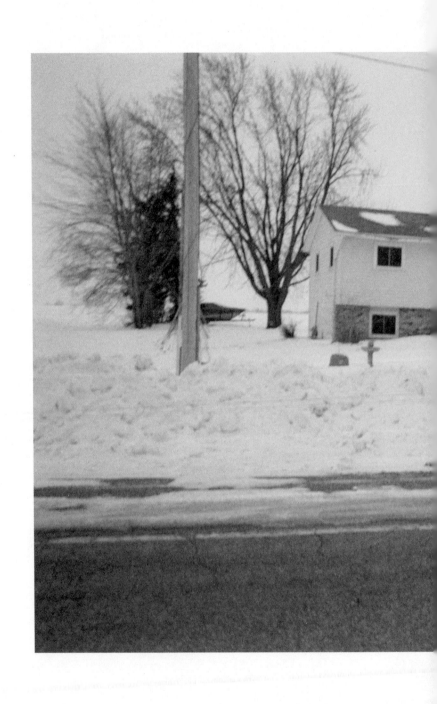

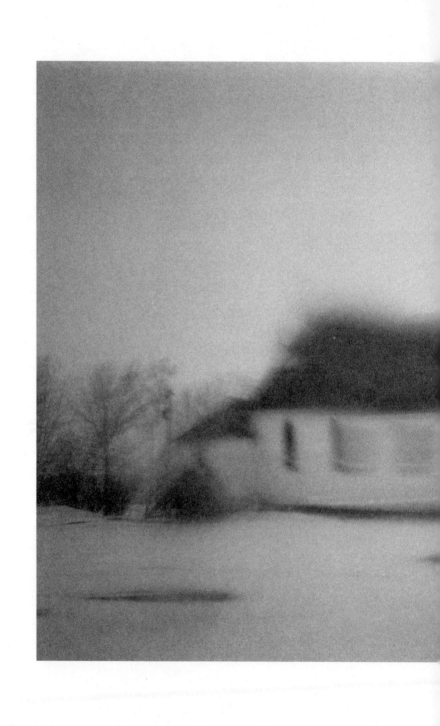

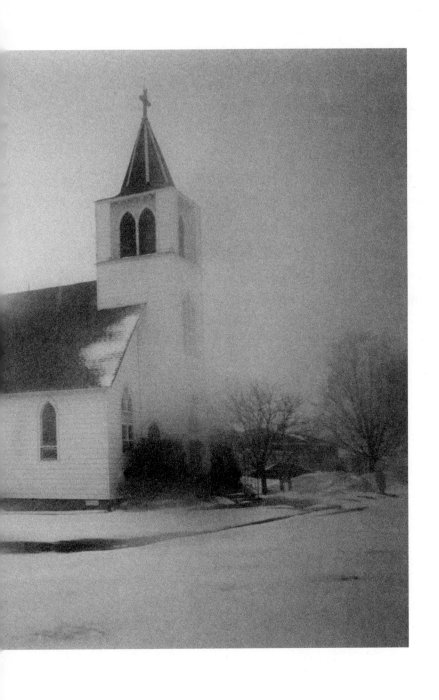

LESTER HAD ALWAYS wanted a dog, but he couldn't be sure he was capable of such a potentially complicated form of collaboration, and knew that he was not the sort of man to abandon a dog. In the past he'd gone on occasion to animal shelters to look at the orphans, and he had been sorely tempted. And he remembered that his resistance had been based on some ethical logic that had startled him at the time: a man shouldn't get involved with any breathing thing that depends on him unless he's prepared to go all in.

LESTER TRIED TO think the thing through, but his habitual defenses were proving useless. Majel had been over it with him; she somehow knew exactly where he was. When the view both in front of and behind you is insufferable, she had said, there are but two ways left to look: up or down. What did he stand to lose by casting his eyes heavenward for a change? What would it hurt to look?

This, of course, was Pascal's wager in a nutshell, and Lester understood as much. Still, why couldn't he embrace righteousness and rapture as easily as he had embraced despair? Where was there left to go? There was no one left to hide from, Majel told him, not even God. And once he accepted that God had seen him there was no hiding place at all.

It was probably nonsense, Lester thought, but was it worse than any other nonsense?

SOMEWHERE OUT THERE in that depressed
tangle of survivors and garbage was an old church
presided over by a priest who had clearly been sent
there as some sort of punishment. Some said it
had something to do with political rabble-rousing
during the Vietnam War, others that he'd been
implicated in a child abuse scandal.

The man didn't have more than a dozen reliable
parishioners, most of them elderly, but the church
itself obviously had some history.

There was an overgrown cemetery behind the
church, and the priest had a picnic table among
the jumble of tombstones. He was said to sit out
there in decent weather playing solitaire or chess
with himself.

Majel wasn't a Catholic, but there weren't anything
but Catholic churches out along that stretch of
the road, and this fellow, she said, was more or less
running a pirate ship. She liked his intensity and
the way that his loneliness erupted in rambling and
passionate sermons that often conveyed nothing
more coherent than pure torment and a longing

for deliverance. Over the years the priest had apparently come to embrace a decidedly apocalyptic, Old Testament theology, which wasn't really all that hard to understand, given the desolation that stretched away on all sides around the church.

Or maybe, Lester thought, the man was just grateful for the appearance of any sort of prospective believer, and perfectly willing to play the wild-eyed Pentecostal if that was what they wanted.

Majel took Lester out there one Saturday afternoon in late March.

The priest walked with them among the graves. He was a wild-looking character, the Walt Whitman archetype. He had dark eyes like Majel's, and he seemed to look right through you.

"A meeting of the holy men," Majel said when she introduced Lester.

"A meeting of the men full of holes," the priest said, and laughed into his chest.

They walked around a bit and made small talk. The priest asked after Majel's father. "Spring must be just around the corner," the priest said. "Just not here, unfortunately."

Lester didn't have much to say, but sensed that he might find plenty to talk about with the priest if the right opportunity presented itself.

At one point Majel took Lester by the arm and said to the priest, "I'm looking to find a way to steer this zigzagging fellow through the straight gate, and I'd like you to help me."

The priest pondered this for a moment.

"The straight gate business is not technically in my purview," he said.

"You know the way," Majel said.

"I suppose that I do."

"I need to get Lester in the river," Majel said.

"And how does Lester feel about that?"

"I'll go in the river," Lester said.

"I'd be happy to baptize Lester in the sanctuary right now," the priest said.

"I want him in the river," Majel said. "A drowning man's got to come up out of the river to be saved."

The priest chuckled, and then shrugged. "I'll go in the river with Lester, but you realize, of course, that there's a damn good chance that we'll both be nothing but swept away."

They went into the church and into a little office heaped with books. The priest dug around on his desk and came up with a calendar. Lester pulled up a chair and looked at the images of the bloody and suffering Christ that were everywhere on the walls. He noticed a copy of Borges's *Ficciones* on a shelf, leaning against an edition of *Waiting for Godot*. He felt as if he'd come to the right man, and he was prepared to be swept away.

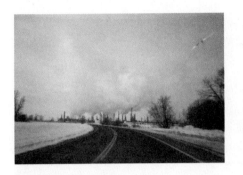

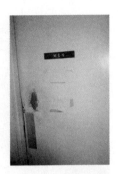

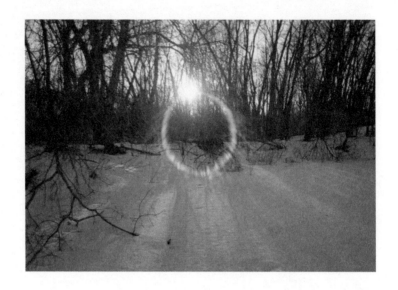

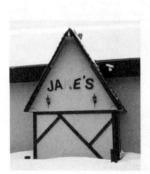

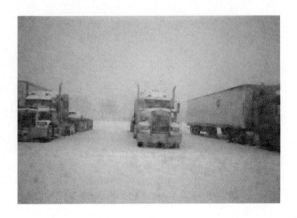

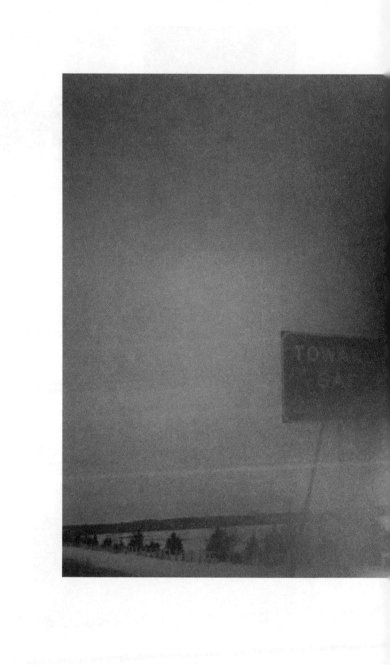

THEY WENT OUT to the river on the last weekend in April. It was a gray day, warm and full of improbable birdsong. The river was brown and high and moving along at a good clip through a typically nondescript patch of countryside. Majel had brought her father, and when they got to the boat launch just upstream from a railroad trestle he had turned to Lester and said, "You damn fool."

The priest was already there waiting for them, smoking a cigarette down by the river's edge and probing the water with a long stick. He walked back to the car and fetched an old white choir robe that he handed to Lester. "For the sake of the spectacle," he said. "Maybe it'll help you float."

Lester walked to the water with the priest and they removed their shoes. Majel had one of Lester's disposable cameras and was holding it to her chest as if it were a bouquet of flowers. She had brought along a folding chair for her father, and he was sitting farther up the bank.

"This is of course a new and unconventional experience, even by the standards of my profession,"

the priest said to Lester. "May your life prove to be such a curious endeavor." He then turned to Majel and asked if she had prepared any remarks.

"Just how proud I am of Lester and how crazy and handsome he looks when he smiles," she said.

The priest took Lester's arm and led him a few steps into the water.

"He's got to go all the way in," Majel said.

"I'll get him all the way in," the priest said.

The water was very cold. Out in the current of the river there was a steady procession of debris being carried along by the force of the water. Lester heard the priest speak his name and was startled.

"Lester B. Morrison," the priest said. "You are beloved of God and of those gathered here today. May this mean to you what it will, and signify what it is intended to signify, and may you feel purified and free from all your burdens. I offer you in lieu of gospel a secular text that nonetheless

gets straight to the heart of man's boundless capacity for patience with God:

> A man goes far to find out what he is—
> Death of the self in a long, tearless night,
> All natural shapes blazing unnatural light.
> Dark, dark my light, and darker my desire.
> My soul, like some heat-maddened summer fly,
> Keeps buzzing at the sill. Which I is I?
> A fallen man, I climb out of my fear.
> The mind enters itself, and God the mind,
> And one is One, free in the tearing wind."

He turned to Majel on the shore. "Is that sufficient?"

Majel nodded and said, "Amen."

"Yes, amen," the priest said. He guided Lester out a few more feet into the water so that they were both standing in the river up to their hips. "Now just relax your body, son, and let yourself go straight back. Majel wants you all the way in, but I'll keep ahold of you. I'll count to three." He placed one hand on Lester's shoulder and the other in the small of his back.

"Straight back now, on three." The priest counted backwards, and on one Lester went down and under the water. He opened his eyes and saw bubbles of light and a fractured vision of the priest trying to hold on to him and the white choir robe rippling at the surface of the river like one of Georgia O'Keeffe's white trumpet flowers.

Lester wanted to stay down there for a time, for Majel, who was now bouncing up and down on the bank and clapping her hands. Lester watched his legs kick slowly and the slow wing-beating of his arms and time seemed to come to a momentary stop.

*How do you feel, baby?* Majel was going to ask him when he came back out, and Lester was already thinking about that question as he held his breath and finally pulled himself free of the priest's grasp and allowed himself to drift farther out into the current where he could feel the water move him.

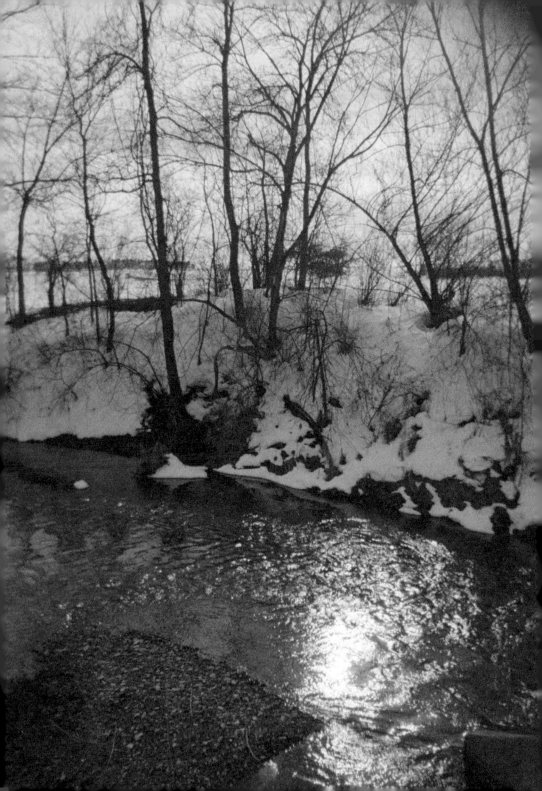

# LESTER BROKE ME

by J. K. Bergen

IN 2012 I WAS CONTACTED by an old
high school friend who had become an editor
at a magazine called *Grindstone+Garden*.
He asked if I might be willing to write something
about a man named Lester B. Morrison
and a new book called *House of Coates*. His
e-mail included several links with background
information on both the man and the book.
Nothing in these materials struck me as
particularly interesting, but I nonetheless asked
my friend to send me a copy of the book for
additional consideration.

After I had read *House of Coates* all the way
through I was puzzled by the point of view and the
relationship between the author and his subject.
What was it? An intimate, analytical omniscience?
Third person, certainly, but also oddly familiar
and largely speculative. The narrator seemed
to be a sort of shadow protagonist in the life of

Lester B. Morrison, but the exact nature of the relationship was unclear.

The original edition of the book was published by an outfit called Little Brown Mushroom, and the copy I had came with no explanatory text beyond the actual narrative between the covers. The cover page, however, indicated the book's author was Brad Zellar, and credited the dozens of often murky, banal, and vaguely terrifying photos to Lester B. Morrison. Upon further investigation I learned that Little Brown Mushroom was owned and operated by Minnesota photographer Alec Soth. Morrison had previously contributed several zines to the Little Brown Mushroom catalog, all of which bore titles that—as with Soth's publishing enterprise—utilized Morrison's initials: *Lost Boy Mountain, Lester Becomes Me, Library for Broken Men,* and *Lonely Bearded Men.* Elsewhere I found a number of articles that offered a bit more information regarding Morrison and his relationship with Soth, whom he had allegedly met while Soth had been engaged in a project that took him all over the country in search of all manner of American outcasts and outsiders: hermits,

monks, survivalists, and generally stunted, asocial loners and oafs. That project yielded a book called *Broken Manual*—a now almost mythical object, apparently; it appears to be virtually unattainable—that is officially credited as a collaboration between Soth and Morrison.

Morrison had been stumbling around in the peripheries of Soth's career for a number of years. In 2009 he had appeared with Soth at a gallery opening in Minneapolis, but that is the only public sighting of the man for which I have been able to obtain corroboration. I'll admit that I initially found the photos from that occasion to be convincing; the man looks almost exactly as I would imagine him to look based on the portrayal in *House of Coates*—shaggy, bearded, slightly boozy, and a bit paunchy and swaybacked.

I got in touch with my editor friend in Chicago and told him that I would be interested in writing about *House of Coates,* but I felt it was imperative that I get to the bottom of the Lester B. Morrison story in order to do so. To do that, I said, I would need to go to Minnesota. He said

that the magazine wasn't in the habit of paying for expenses. I told him that I didn't much care; if they paid me for the story I would manage the expenses on my own.

Before signing off he encouraged me to get in touch with Soth and Zellar, over the next couple days I had brief correspondence with both of them. Soth sounded both bemused and exhausted. "I guess I look at *House of Coates* as sort of the end of my relationship with Lester," he said. "He played a big role in the *Broken Manual* project, but it takes a lot of time and energy to keep up with someone like that, and I've just decided it's time for me to move on."

Zellar was only slightly more helpful, at least initially. He agreed to answer whatever questions I might have, and I promptly sent him a list. Lester, he wrote me back, was Soth's associate. He himself had spent one long, frustrating year trying to pin Morrison down for a profile for the catalog of an exhibition in Krakow. Over that time he said he had received a smattering of e-mails, presumably sent from public library

computers and bearing a confusing number of
e-mail addresses. He had never received a direct
response when replying to any of these messages;
rather, he would receive another message from
a different e-mail address. I asked if he would
be willing to provide me with some of these
addresses. I sent queries to each and received
either bounce-backs or no reply.

Zellar claimed that in the winter of 2011 he had
received a message from Morrison requesting
a meeting at the café of the Travel Plaza, an
enormous truck stop located on Highway 52 south
of the Twin Cities near the small community of
Coates. He recalled driving in a blizzard and then
sitting alone in a booth at the café for two hours.
Morrison didn't show, but Zellar spent some time
making inquiries in the area and was able, he said,
to somewhat pinpoint Morrison's orbit. The entire
area is dominated by a monstrous and sprawling
oil refinery, and Zellar stumbled across a shabby
rooming house where Morrison (according to
the proprietor) had recently been staying. This
rooming house consisted of six sleeping rooms
above a bar, with two shared bathrooms in the

hallway. Frustrated by Morrison's no-show, Zellar arranged to rent the one available room. He paid the man for two weeks, drove back to Minneapolis to retrieve clothing and provisions, and returned the next day to resume his search for Morrison. "It was a very dark and curious time," Zellar wrote to me. "And I think the book is a pretty faithful depiction of those two weeks and what Lester was up to down there."

At some point during his stay in the rooming house in Hampton, Zellar said, he returned to his room to discover a large envelope that had been slipped under his door. Inside this envelope he found what he eventually surmised were the results of a Minnesota Multiphasic Personality Inventory, complete with the administrating psychiatrist's notes. When I pressed Zellar for specific information he might have gleaned from this document, he demurred. "It was a huge help, obviously," he said, "and also a confidence. I want to protect Lester and respect that confidence, but I think it's fair to say that much of the speculative material in *House of Coates* has its source there."

In one of my last correspondences with Zellar he wrote that two weeks after he returned to Minneapolis to write about Morrison for the Krakow exhibition catalog, he had received in the mail a shoebox, overzealously wrapped with duct tape and marked "PERISHABLE." Inside were two dozen disposable cameras and a note that read, "Dubious documents of the approximate period in question." The photographs that were extracted from these cameras—or at least a sampling of them—are those that are paired with Zellar's text in *House of Coates*.

I made plans to travel to Minnesota during the first week of April. I was living in Iowa City, and had a break. Before I left I had e-mailed Soth's studio in St. Paul to ask if it was possible for me to pay a visit and look at copies of some of Morrison's works. The afternoon I stopped by, Soth was out of the country. When I explained the purpose of my trip, Soth's studio manager, Carrie Thompson, gave me a look that might have been interpreted as expressing either pity or scorn. As I sat on a couch, slowly paging through a collection of Morrison's zines—all of which

featured the same crudely assembled mash-up of poetry, doodles, and collage—I asked Thompson if she had met Lester. She hesitated an instant, but then said, "Yes."

I studied her face, detecting no apparent strain or misgivings. "Often?" I asked.

"Not at all," she said, without looking away from her computer.

By the time I drove out of the Twin Cities, heading south on Highway 52, I had every reason to believe that this trip was going to prove worthless. I'd spoken to a few Morrison believers in Minneapolis, but I'd also heard from a number of people who felt that he was at best a composite, at worst a conjoined figment of Soth and Zellar's imaginations. Whatever else *House of Coates* might or might not be, however, I can attest that in both words and pictures it paints a distressingly accurate picture of the territory in which I suddenly found myself. The landscape around the oil refinery that is a prominent feature in the book is marked by unrelenting and

toxic desolation. Ironically, I suppose, the one place along that bleak stretch of highway that is at least somewhat welcoming is the rather cozy bar and restaurant whose name provides the book's title. I enjoyed a very large and quite delicious hamburger on the afternoon of my visit to the House of Coates, and found both the establishment and its clientele to be clean and welcoming. No one I talked to had ever heard of the book. Several patrons at the bar took turns thumbing through my copy, and seemed nothing if not puzzled by it. The brick-and-mortar House of Coates, furthermore, does not, as the book implies, offer any sort of accommodations. I tried to explain to the patrons both the book and my reasons for visiting the area. I met a number of people who professed to know Morrison's name, and a handful of others who insisted they had crossed paths with him at some point. Nothing in the way of concrete details emerged from any of these conversations, however, and not one person I spoke with had ever heard of Majel Eames, the woman Lester meets at the Travel Plaza in *House of Coates*.

I found one Eames—R. L. Eames—in the local telephone directory. This person lived in the nearby community of Vermillion. While attempting to locate the home of R. L. Eames I stumbled across the church that provides one of the book's most striking images. Time and again in my investigations, in fact, I found myself staring at real-world versions of photographs from *House of Coates*. It was unsettling, I must say. There was an uncanny and ugly accuracy at work, and seeing those places and things only served to heighten my sense that there was something very real and yet elusive going on.

The church was locked up tight. There was indeed a forlorn and unkempt cemetery behind the church. I fetched one of the Lester photos from my car, taped it to the front door of the church, and wrote upon it my contact information and the words "Have You Seen This Man?"

Not far up the road I found the home of R. L. Eames. I knocked on the door for at least two minutes before it was answered by an elderly man

with a walker. I asked for Majel. "No one by that name lives here," the man said.

"Do you have a daughter?" I asked.

"I have two," the man said, "but neither of them lives here."

I told him I was looking for a man named Lester B. Morrison. "Listen, fella," he said, "I don't know what you're up to coming by here, but I'm not looking for any trouble." He slammed the door. I went back and sat in my car for a few minutes, staring at the house and thumbing through my copy of *House of Coates*. I was almost 100 percent certain that the Eames' place was one of those pictured in the book.

As I drove back north on Highway 52 I was starting to feel both foolish and depressed. I'm sure a good deal of this had to do with the bleak and downtrodden landscape, blank skies, and general atmosphere of fouled industrial waste. Eventually, I found the actual rooming house depicted in *House of Coates*. A woman who

worked in the bar downstairs showed me the only two available rooms, both of which were stale repositories of deviant DNA. There was no mistaking the place. The doors to two of the occupied rooms were open, and the lodgers were both sitting alone on straight-backed chairs, smoking and staring at televisions. Either of those men could have been Lester B. Morrison.

I asked the woman if Lester's name rang any bells. "He supposedly spent some time here," I said.

"When was this?"

I told her the winter of 2011 and she gave it some thought. "Beard?" she said, "Guy who takes pictures?"

"Yes," I said, trying not to get excited. "That sounds like him."

"He wrote on the fucking walls," she said.

"What did he write?"

She stepped across the hallway and, straddling the threshold of one of the rooms, pointed at the paneling above the bed. With her other hand she flipped the light switch. I stepped into the room and followed her finger. In my memory I actually crouched like a television detective and crept in for a closer look. And there, not written but scratched as if with a razor blade, was one ragged word—*Harpazo*—and seeing it there on the wall of that shabby room sent a chill up my spine. Anyone could have scrawled it there, of course; Zellar might have done so himself or merely seen it and used it as a launching point for his story. Regardless, in that moment I at least finally and truly considered myself in the midst of a mystery worth unraveling.

I was staying at a nearby strip motel that advertised weekly and monthly rates. At the time of my visit there appeared to be no other guests other than a couple more Lester characters who were clearly residents. In my room, I sat down on the bed and worked for a couple hours arranging my notes trying to draw a map of all the locations in *House of Coates*. I was starting

to have fun, and was beginning to piece together the story I would write.

I woke up the next morning to discover that someone had broken into my car. I can't imagine I had a single item in the vehicle that in any way translated to the currency of that debased place, but they took everything anyway. I called AAA to fix the broken window, decided against filing a police report, and drove to a nearby McDonald's in search of wifi. In the parking lot I started up my laptop. The first e-mail in my inbox was from one of the Lester B. Morrison addresses that Zellar had provided. In the subject field were the words *Lies Become Myths,* and there was a link that took me to a Google map on which was highlighted a Maple Grove Cemetery near a town called Stanton. According to the map, Stanton was a bit south and west of where I was. As I was mulling this new piece of the puzzle another message popped up, from the same address: "He's there, but gone on from there." I tapped out a hurried reply—"Who is this?"—and hit send. For twenty minutes I sat there, staring at the screen of my laptop. No response. I got back on Highway

52, headed south in search of the Maple Grove Cemetery.

It was perhaps a half-hour drive, and the cemetery was located in the country, just off a badly potholed two-lane country road. Muddy and still-frozen fields stretched away into the distance on all sides, and in every direction I could pick out the water towers and steeples of the myriad townships scattered all over that part of the flat Minnesota countryside. No one was around, but there was a small caretaker's cottage with a sign on the door announcing basic rules and regulations. At the bottom was a phone number. I dialed this number and a man answered on the first ring. I explained that I was standing at the gate of the cemetery and was hoping for a bit of assistance on possibly locating a grave. "I might be able to help you," the man said. I asked with whom I was speaking. He said his name—Martin Grimaldi, it sounded like—and claimed to be the sexton for the cemetery. "It's one of several I look after," he said.

I told him I was looking for the grave of Lester B. Morrison. "He's in there," he said. "Or there's a

marker, at any rate. I don't believe anything's ever been buried in there."

"That sounds unconventional," I said.

"People sometimes want a plot and a marker," he said. "It's possible that they spread the ashes themselves, but that's illegal. There's no casket in there, though; I can tell you that much."

I asked how I might find Lester's marker. "It's one of the newer ones," he said. "We're running out of room, so the last plots are all back along the fenceline on the north side. He should be back there."

"But he's not really back there?" I said. "I'm sorry, but I'm just trying to get this straight."

"Not to the best of my knowledge," he said, "but I can't be certain. I just look after the place and keep the records. I know I've never put a body in that hole."

I asked if he knew who bought the plot and marker. "There *is* a marker, correct?"

"There's a headstone, yes," he said. "Got his name on it. As for who paid for it, I'm not in that loop. I don't handle any money."

"But you must have some information about who owns the plot," I said. "Or is that not the case?"

"I could tell you that, I suppose. Woman named Nichelle Herrimann," he said, and spelled it out for me. "The stone was installed not quite a year ago. Last May."

I asked if he knew anything about either of these people—Morrison or Herrimann. He didn't. I was slogging through the slush and mud of the cemetery as I was talking to the sexton, and as he spoke his last sentence I was standing at Lester B. Morrison's grave. There were no birth or death dates, but beneath his name had been carved the same phrase that had been the subject heading on the e-mail I received earlier in the morning: *Lies Become Myths*.

I don't know how long I stood there, but it felt like an eternity. I noticed that I had written Nichelle

Herrimann's name on my palm, so I drove to the nearest McDonald's and immediately googled her. I got as far as the first name when dozens of pages related to an actress named Nichelle Nichols began to load beneath the search field. I clicked on the Wikipedia link; Nichelle Nichols had played Lieutenant Uhura, one of the original characters on *Star Trek*. I'd never seen the show, had scrupulously avoided it all my life, but in *House of Coates* Lester's strange lady friend, Majel Eames, is said to have been named for a *Star Trek* actress.

There were no search results for anyone named Nichelle Herrimann.

I let this information sink in, and as it did I found that I was rocking wildly, pounding at the steering wheel with my fists, and shouting, over and over, "What is this? What is this? What the fuck is this?"

While I was still sitting in my car I sent Zellar an e-mail. "I was just standing at a grave that had a marker with Lester's name on it," I wrote. "What the fuck is going on? What's the story here? Be straight with me."

Zellar got back to me maybe five minutes later. "Wow," he wrote. "Those are some pretty good questions."

I wrote back immediately and told Zellar to fuck himself. And then I drove back to Iowa City and wrote my piece for *Grindstone+Garden,* a story nobody read that appeared in a magazine that no longer exists.

And so I'll leave you (whoever you are) with this: True or false. Fact or fiction. Dead or alive. I don't care anymore. Lester B. Morrison? You can have him.

COLOPHON

*House of Coates* is set in DeVinne
and Saa Series A D.

FUNDER ACKNOWLEDGMENTS

Coffee House Press is an independent, nonprofit
literary publisher. All of our books, including the one
in your hands, are made possible through the generous
support of grants and donations from corporate
giving programs, state and federal support, family
foundations, and many individuals who believe in the
transformational power of literature. We receive major
operating support from Amazon, the Bush Foundation,
the National Endowment for the Arts—a federal
agency, and Target. Our activity is also made possible
by the Jerome Foundation, the McKnight Foundation,
the Wells Fargo Foundation of Minnesota, and the
voters of Minnesota through a Minnesota State Arts
Board Operating Support grant, thanks to a legislative
appropriation from the arts and cultural heritage fund.

Coffee House Press receives additional support from the
Elmer L. & Eleanor J. Andersen Foundation; the David
& Mary Anderson Family Foundation; the E. Thomas
Binger and Rebecca Rand Fund of the Minneapolis
Foundation; the Patrick and Aimee Butler Family
Foundation; the Buuck Family Foundation; the Carolyn
Foundation; Dorsey & Whitney Foundation; Fredrikson
& Byron, P.A.; the Lenfestey Family Foundation; the
Nash Foundation; the Rehael Fund of the Minneapolis

Foundation; the Schwab Charitable Fund; Schwegman, Lundberg & Woessner, P.A.; the Private Client Reserve of US Bank; the Archie D. & Bertha H. Walker Foundation; and the Woessner Freeman Family Foundation.

JEROME FOUNDATION Celebrating the creative spirit of emerging artists 50 YEARS

THE MCKNIGHT FOUNDATION

To you and our many readers across the country, we send our thanks for your continuing support.

THE PUBLISHERS CIRCLE is an exclusive group recognizing those individuals who make significant contributions to Coffee House Press's annual giving campaign. Understanding that a strong financial base is necessary for the press to meet the challenges and opportunities that arise each year, this group plays a crucial part in the success of our mission.

For more information about the Publishers Circle and other ways to support Coffee House Press books, authors, and activities, please visit coffeehousepress.org/support/ or contact us at: info@coffeehousepress.org.

Jocelyn Hale &
Glenn Miller

Roger Hale & Nor Hall

Jeffrey Hom

Stephen & Isabel Keating

The Kenneth Koch
Literary Estate

Allan & Cinda Kornblum

Kenneth Kahn &
Susan Dicker

Kathryn & Dean Koutsky

Leslie Larson Maheras

Jim & Susan Lenfestey

Sarah Lutman

Carol & Aaron Mack

George Mack

Joshua Mack

Sjur Midness &
Briar Andresen

Peter Nelson &
Jennifer Swenson

Marjorie Welish

Stu Wilson &
Melissa Barker

Margaret Wurtele

## BRONZE ($500–$999)

Brian Alexander

Emil & Marion Angelica

Kate Bernheimer

Patrick Coleman

Jean Doumanian

Randy Hartten &
Ron Lutz

Benjamin Heineman

Dylan Hicks & Nina Hale

Carl & Heidi Horsch

Steve McDermid &
Katie Windle

Ron Padgett

Sam Savage

Kiki Smith

Marla Stack & Dave Powell

Stewart Stone

Betty Jo Zander &
Dave Kanatz

Visit us at
coffeehousepress.org.

## OUR MISSION

The mission of Coffee House Press is to publish exciting, vital, and enduring authors of our time; to delight and inspire readers; to contribute to the cultural life of our community; and to enrich our literary heritage. By building on the best traditions of publishing and the book arts, we produce books that celebrate imagination, innovation in the craft of writing, and the many authentic voices of the American experience.

## VISION FOR THE FUTURE

We will be leaders in reimagining the role of a literary publisher by shifting from being an organization that produces books into one that also designs and produces literary and reading experiences.

LITERATURE
is not the same thing as
PUBLISHING